This book is for

Copyright © 2019 by Freyja Stacey All rights reserved. No part of this book may be reproduced in any form or by any electronic or mechanical means, including information storage and retrieval systems, without written permission from the author, except for the use of brief quotations in a book review.

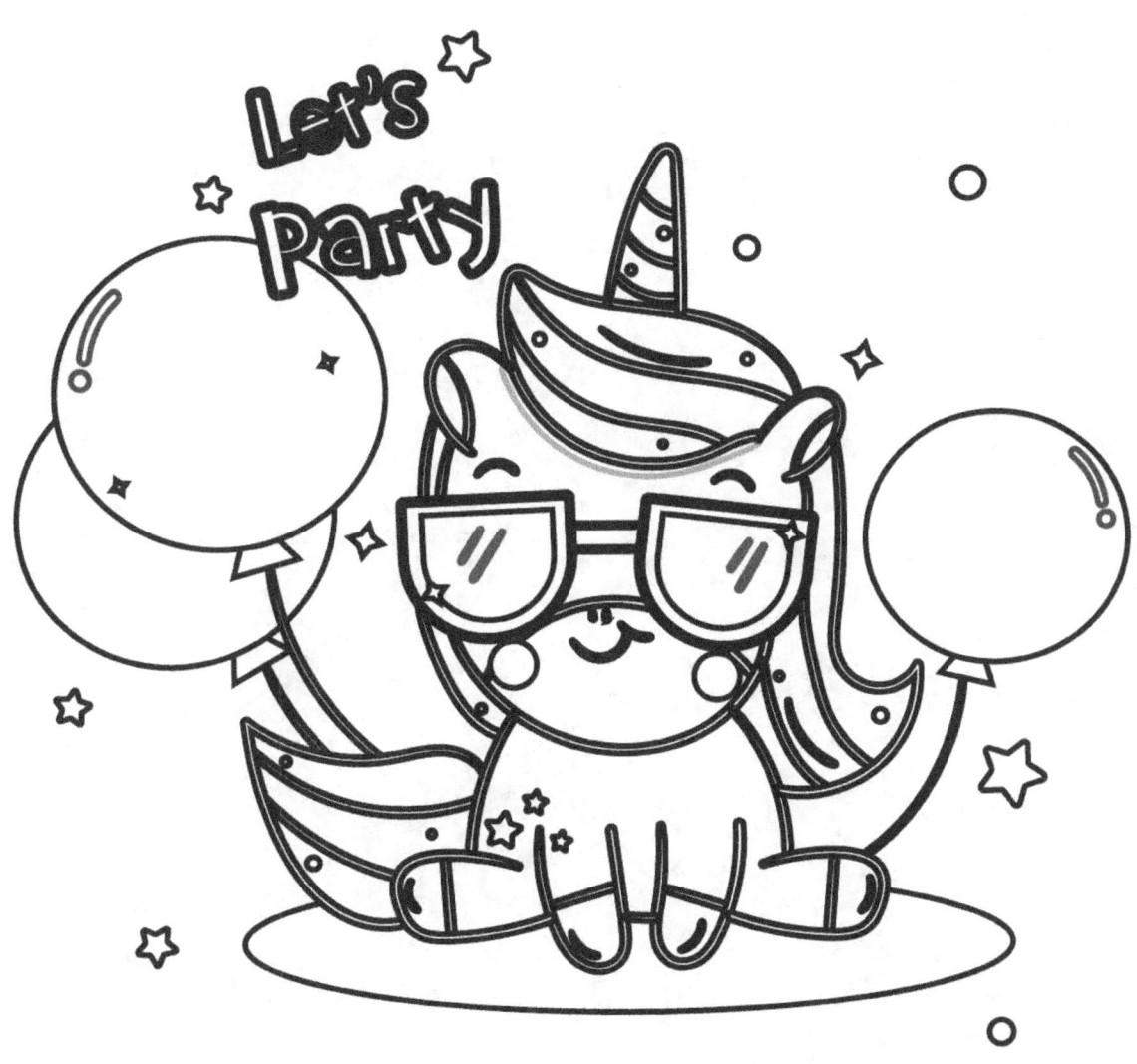

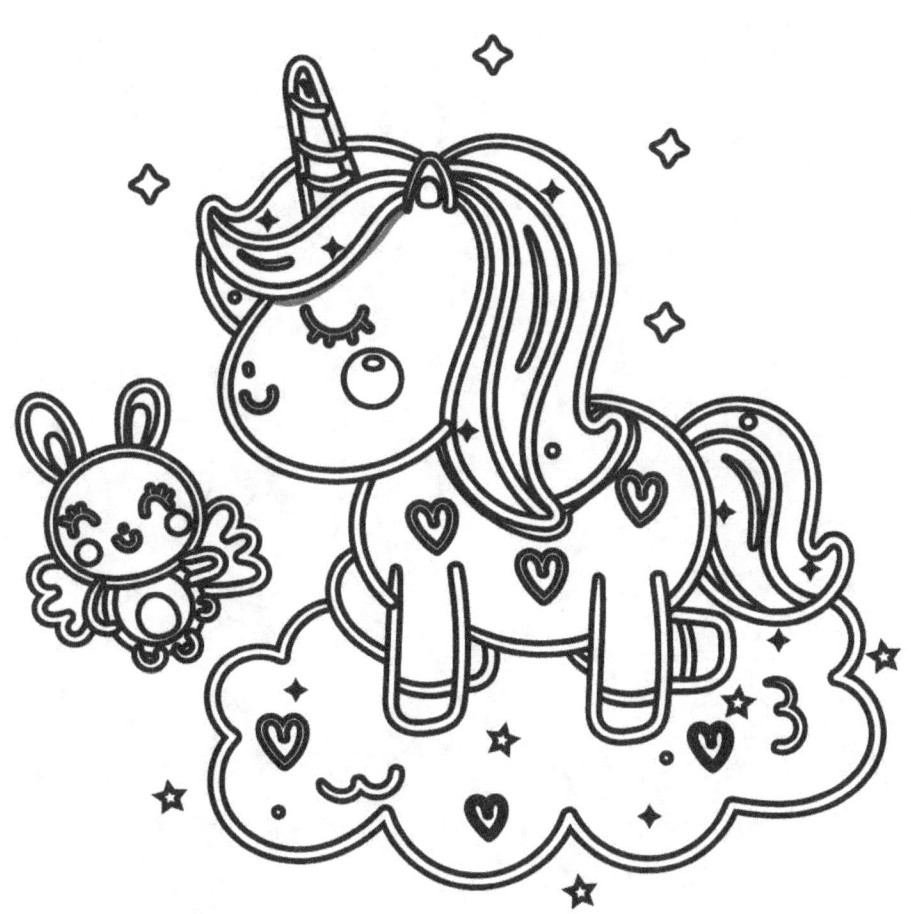

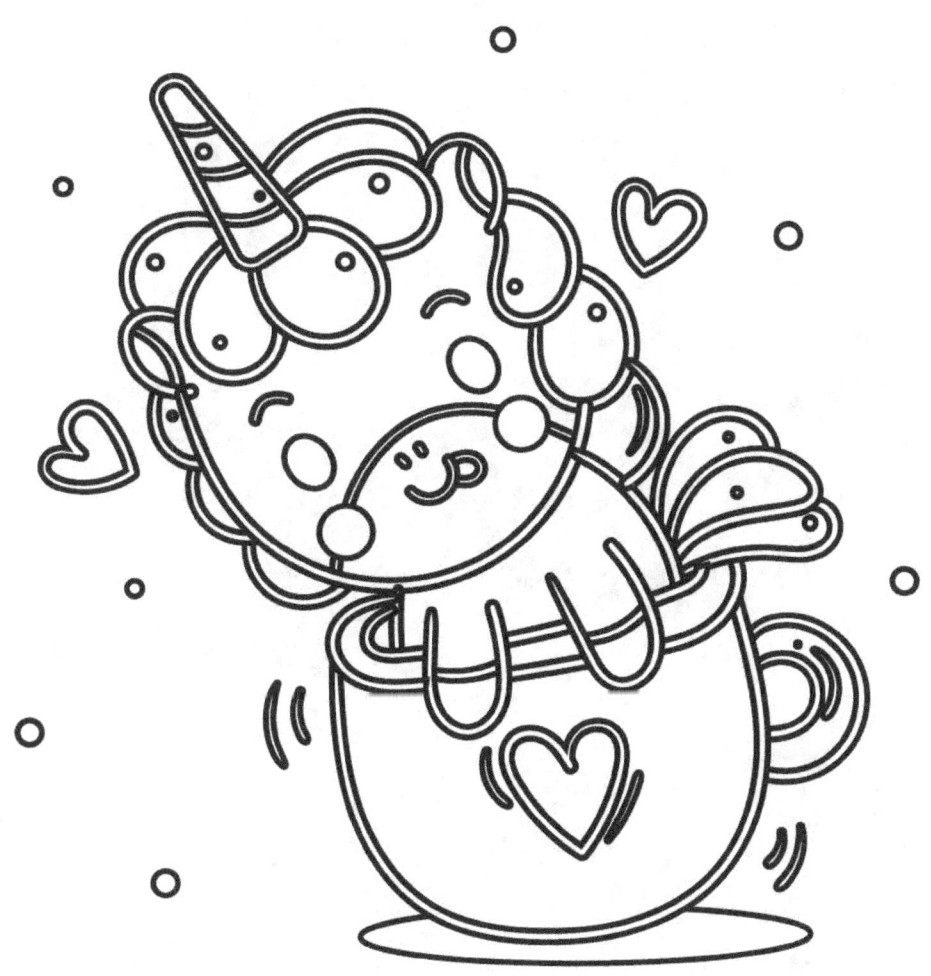

www.ingramcontent.com/pod-product-compliance
Lightning Source LLC
Chambersburg PA
CBHW080910220526
45466CB00011BA/3536